CW00538291

FOREIGN-LANGUAGE
ALPHABETS

FOREIGN-LANGUAGE ALPHABETS

100 COMPLETE FONTS

Selected and Arranged by

Dan X. Solo

from the
Solotype Typographers Catalog

DOVER PUBLICATIONS, INC.
Mineola, New York

Copyright

Copyright © 1999 by Dover Publications, Inc.
All rights reserved under Pan American and International Copyright Conventions.

Published in Canada by General Publishing Company, Ltd., 30 Lesmill Road, Don Mills, Toronto, Ontario.

Bibliographical Note

Foreign-Language Alphabets: 100 Complete Fonts is a new work, first published by Dover Publications, Inc., in 1999.

DOVER *Pictorial Archive* SERIES

Library of Congress Cataloging-in-Publication Data

Foreign-language alphabets : 100 complete fonts / selected and arranged by Dan X. Solo
 from the Solotype Typographers catalog.
 p. cm. — (Dover pictorial archive series)
 ISBN 0-486-29704-7 (pbk.)
 1. Printing—Specimens. 2. Type and type-founding. I. Solo, Dan X. II. Solotype
Typographers. III. Series.
Z250.F69 1999
686.2'24—dc21 97-1068
 CIP

Manufactured in the United States of America
Dover Publications, Inc., 31 East 2nd Street, Mineola, N.Y. 11501

A note about the alphabets.

The hundred alphabets in this book are used in printing more than fifty of the world's principal languages. A few, like Anglo Saxon, may be of interest only to scholars, but most are commercial languages read by large numbers of people.

Some languages omit one or more of the 26 letters we use in English, but all type fonts the world over include the full complement of letters so that words borrowed from other languages can be accommodated. The Cyrillic alphabet is used in many of the Eastern European countries. Arabic scripts are widely used in the Middle and Near East.

Most languages are living, and therefore changing. Accents that were used fifty or a hundred years ago are today reduced in number or dropped altogether. Compare the Albanian alphabets on the next two pages, one old with nine accents and special letters, and one modern with only the six that are now used.

We have made a good effort toward accuracy, but would be pleased to hear from readers who have reliable knowledge of changes or additions that would improve subsequent editions of this book.

Albanian

Franklin Gothic Condensed

AÁBCÇDEÉËĖÉFG

HIÍJKLMNOÓPQ

RSTUÚVWXYÝZ

(&;!?)

aábcçdeéëĖ́ɛɛ́fg

hiíjklmnoópqr

stuúvwxyýz

$1234567890

Albanian

Century Old Style

AÁBCDEÉË
FGHIÍJKLMNOÓ
PQRSTUÚV
WXYÝZ
(&;!?)
aábcdeéëfg
hiíjklmnoópqr
stuúvwxyýz
1234567890

Anglo Saxon

Century Old Style Roman

AĀÆǢBCDEĘĒ

FGȝHIĪJKLMNOŌǪ

ÐÞPQRSTUŪV

WXYȲZ

(&;!?)

aāæǣbcdeēęfȝgh

iījklmnoōǫðþpqrst

uūvwxyȳz

$1234567890£

Arabic
Hadeeth Extrabold

ث ث ث ث ت ت ت ت ب ب ب ب ا ا

خ خ خ خ ح ح ح ح ج ج ج ج

ش س س س س ز ز ر ر ذ ذ د د

ض ص ص ص ص ص ش ش ش ش

غ ع ع ع ظ ظ ط ط ط ط ض ض

ك ك ك ك ق ق ق ق ف ف ف ف غ غ خ

ه ه ه ن ن ن ن م م م م ل ل ل ل ك

ء ى ى ـ ـ ة ة ي ي ي ي لا لا و و

۱۲۳٤٥٦۷۸۹۰) (؟ ! ؛ : ، .

Arabic
Thuluth Light

ا ا ب ب ب ب ت ت ت ت ث ث ث ث

ج ج ج ج ح ح ح ح خ خ خ خ

د د ذ ذ ر ر ز ز س س س س ش

ش ش ش ص ص ص ص ض ض ض ض

ض ط ط ظ ظ ع ع ع ع غ غ غ غ

غ ف ف ف ف ف ق ق ق ق ك ك

ك ك ك ك ك ل ل ل ل م م م م ن

ن ن ه ه ه ه و و و لا لا آ ي ي ي ي ي ة

ـ ـ ـ ى ء ء ـ ـ ـ ـ ؤ ؤ ئ ئ إ أ ـ

»« () (؟!؛،:.. ٠٩٨٧٦٥٤٣٢١

Arabic

Handasei Bold

ا ب ب ب ت ت ت ث ث ث ج ج ج ح ح

خ خ د ذ ر ز س س ش ش ص

ض ض ط ظ ع ع ع غ غ

غ غ ف ف ف ق ق ق ك ك ل ل م

م م ن ن و و ه ه ه ه لا لا ي ي

ي ي ة ة ر ر ى ك ء ـ ـ ـ ـ ـ ـ

! ؟ . . ، ؛ [] ٠ ٩ ٨ ٧ ٦ ٥ ٤ ٣ ٢ ١

Arabic
Ad Headline Bold

ا ا آ أ ا ب ت ت ث ج ج ح خ د خ ذ د ذ

ر ز س س ش ش ص ص ض ض ط

ظ ع ع غ غ ف ف ق ة ق ك ك ل ا لا

م م م ن ة ه و لا لأ ي ي

١٢٣٣٤٥٦٧٨٩٠.،؛:!إ؛“”(())

Arabic
Marakishi Medium

ا ب ـب ـت ـت ث ـث ج ج ج ح
ح ح خ ـخ ـخ د د ذ ذ ر ز س س
ش ش ص ص ص ض ض ض ض
ط ظ ع ـع ـع غ غ غ غ ـف ف
ق ق ق ك ـك ل ل م م م ـن ن
ه ه ه و و و لا لا ي ي ي ي ة
ى ى ى ء ء ـ ـ

۱۲۳٤٥٦۷۸۹۰)(؟!؛؛،.

Armenian

Aramian

ԱԲԳԴԵԶԷԸԹԺԻ
ԼԽԾԿՀՁՂՃՄՅՆՇ
ՈՉՊՋՌՍՎՏ
ՐՑՒՓՔՕՖ

աբգդեզէըթժիլխծկ
հձղճմյնշոչպջռս
վտրցւփքօֆ
(.,:՞՛՜֊՝)
1234567890

Armenian

Barz

ԱԲԳԴԵԶԷԸԹԺԻ

ԼԽԾԿՀՁՂՃՄՅՆՇ

ՈՉՊՋՌՍՎՏ

ՐՑՒՓՔՕՖ

աբգդեզէըթժիլխծկ

հձղճմյնշոչպջռս

վտրցւփքօֆ

(. , : ՞ ՛ ՜ – ՝)

$1234567890֏

Basque

Clarendon

ABCÇDD̄EFGHIJ
KLĿMNÑOPQRŔ
SŚT̄T̄UÜVWXYZ

&;!? ÆŒæœ

abcçdd̄efghijklĺm
nñopqrŕsśst̄t̄uv
uüvwxyz

$1234567890£

Basque

Avant Garde

ABCÇDD̄EFGH
IJKLL̄MNÑOP
QRŔSŠTT̄UÜVW
XYZÆŒ
«(&;!?)»
abcçdd̄efghijkll̄
mnñopqrŕsštt̄uü
vwxyzæœ

$1234567890£

Catalan

Century Oldstyle Bold

AÀBCÇDEÉÈF

GHIÍJKLL·LMN

OÓÒPQRSTUÚÜ

VWXYZ

(&;!?)

aàbcçdeéèfghií

jkll·lmnoóòpqrstuúü

vwxyz

$1234567890£

Catalan

Century Oldstyle Roman

AÀBCÇDEÉÈF
GHIÍĿLJKLMN
OÓÒPQRSTUÚÜ
VWXYZ
(&;!?)
aàbcçdeéèfghií
jklŀlmnoóòpqrst
uúüvwxyz

$1234567890£

Celtic
Traditional

AÁbḃCĊḊ

eÉḟḞġṠhíĺm

mṅṄoÓpṗRṚ

sṠCṪuÚ

AÁbḃCĊḊḋeÉḟḟ

ġṠhíĺmṁṅṅoÓ

pṗṙṙṠṫṫuÚ⁊

1234567890

Croatian

Nova Bold

ABCĆČDĐEFGHIJ
KLMNOPQRSŠT
UVWXYZŽ
(&;!?)

abcćčdđefghijklm
nopqrsštuvwxyzž

$1234567890£

Croatian

Nova Roman

ABCĆČDĐEFGHIJ

KLMNOPQRSŠT

UVWXYZŽ

(&;!?)

abcćčdđefghijklm

nopqrsštuvwxyzž

$1234567890£

Old Cyrillic

Traditional

ꙗБВГДЄЮЖЅЗꙀІИ
КЛМНОПРСТУФХѠ
ЩЦЧШЪꙐЫЬѢЮ
Ꙗꙗ ѤꙖꙖꙖꙖꙁꙋѮѰѴѶ

аБВГДЄНЮЖЅЗꙀІПЇиꙂК
лмнопрстꙋфхꙗшщц
чшъꙐыꙐьѢюꙖ
ꙖꙗꙗꙗꙗꙗꙗꙁꙋѮѰѴꙋꙋъ

$1234567890£

Cyrillic

Grotesk Light

АБВГДЕЁЖЗИЙ
КЛМНОПРСТУФХ
ЦЧШЩЪЫЬЭЮЯ

абвгдеёжзийклмн
опрстуфхцчшщ
ъыьэюя

«(&;?)»

$1234567890£

Cyrillic
Grotesk Bold

АБВГДЕЁЖЗИЙК
ЛМНОПРСТУФХЦ
ЧШЩЪЫЬЭЮЯ

абвгдеёжзийклмн
опрстуфхцчшщ
ъыьэюя

«(&;?)»

$1234567890£

Cyrillic

News Roman

АБВГДЕЁЖЗИЙ
КЛМНОПРСТУ
ФХЦЧШЩ
ЪЫЬЭЮЯ

абвгдеёжзийклмн
опрстуфхцчшщ
ъыьэюя

«(&;?)»

$1234567890£

Cyrillic

News Roman Bold

АБВГДЕЁЖЗИЙ
КЛМНОПРСТУФ
ХЦЧШЩЪЫ
ЬЭЮЯ

абвгдеёжзийклмн
опрстуфхцчш
щъььэюя

«(&;?)»

$1234567890£

Cyrillic
Century Italic

АБВГДЕЁЖЗИЙ

КЛМНОПРСТУФ

ХЦЧШЩЪ

ЫЬЬЭЮЯ

абвгдежзийклм

нопрстуфхцч

шщъыьэюя

$1234567890£ (&;!?)

Czech

Century Schoolbook Bold

AÁBCČDĎEÉĚ

FGHIĬJKLMNŇ

OÓPQRŘSŠTŤ

UÚŮVWXYÝZŽ

«(&;!?)»

aábcčdďeéěfgh

iíjklmnoópqrřsš

tťuúůvwxyýzž

$1234567890£

Czech

News Roman

AÁBCČDĎEÉĚ

FGHIIĬJKLMNŇ

OÓPQRŘSŠTŤ

UÚŮVWXYÝZŽ

«(&;!?)»

aábcčdďeéěfgh

iíjklmnoópqrřsš

tťuúůvwxyýzž

$1234567890£

Czech

Devinne Ornamented

AÁBCČDĎEÉĚ

FGHIĬJKLMNŇ

OÓPQRŘSŠTŤ

UÚŮVWXYÝZŽ

«(&;!?)»

aábcčdďeéěfgh

iíjklmnoópqrřsš

tťuúůvwxyýzž

$1234567890£

Danish

Ultra Bodoni

AÅBCDEFGHI
JKLMNOØPQR
STUVWXYZÆ

«(&;!?)»

aåbcdefghijklm
noøpqrstuv
wxyzæ

$1234567890£

Danish

News Gothic Demi

AÅBCDEFGHI
JKLMNOØPQR
STUVWXYZÆ

«(&;!?)»

aåbcdefghijklm
noøpqrstuv
wxyzæ

$1234567890£

Dutch

Binner

ABCDEFGHIJ
KLMNOPQRST
UVWXYIJZ

«(&;!?)»

abcdefghijklm
nopqrstuv
wxyijz

$1234567890£

Dutch

Bodoni Medium

ABCDEFGHIJ
KLMNOPQRST
UVWXYIJZ

«(&;!?)»

abcdefghijklm
nopqrstuv
wxyijz

$1234567890£

Esperanto
Garamond Book

ABCĈDEFGĜHĤI
JĴKLMNOPQRSŜT
UŬVWXYZ

(&;!?)

abcĉdefgĝhĥijĵkl
mnopqrsŝtuŭv
wxyz

$1234567890£

Esperanto
Grotesk

ABCĈDEFGĜ
HĤIJĴKLMNOP
QRSŜTUŬVW
XYZ
(&;!?)
abcĉdefgĝhĥijĵ
klmnopqrsŝt
uŭvwxyz

$1234567890£

Estonian

Garamond

AÄBCČDEFGH
IJKLMNOÖÕPQR
SŠTUÜVWXYZŽ

«(&;!?)»

aäbcčdefghijklmn
oöõpqrsštuüv
wxyzž

$1234567890£

Estonian
Clearface

AÄBCČDEFGH
IJKLMNOÖÕPQR
SŠTUÜVWXYZŽ

«(&;!?)»

aäbcčdefghijklmn
oöõpqrsštuüv
wxyzž

$1234567890£

Finnish

Devinne Ornamented

AÄBCDEFGHI
JKLMNOÖPQR
STUVWXYZ

«(&;!?)»

aäbcdefghijklmn
oöpqrstuvwxyz

$1234567890£

Finnish

Candida

AÄBCDEFGHI
JKLMNOÖPQR
STUVWXYZ

«(&;!?)»

aäbcdefghijklmn
oöpqrstuvwxyz

$1234567890£

Flemish

Palatino

ABCDEFGHIJK
LMNOPQRSTUV
WXYIJZ

«(&;!?)»

abcdefghijklmno
pqrstuvwxyijz

$1234567890£

Flemish

City Black

ABCDEFGHIJK
LMNOPQRSTUV
WXYIJZ

«(&;!?)»

abcdefghijklmno
pqrstuvwxyijz

$1234567890£

French

Bodoni Medium

AÀÂBCÇDEÉÈ
ÊËFGHIÎÏJKLM
NOÔPQRSTUÙ
ÛÜVWXYZŒ

«(&;!?)»

aàâbcçdeéèêëfg
hiîïjklmnoôpqr
stuùûüvwxyzœ

$1234567890£

French

Time Script Bold

AÀÂBCÇDEÉÈ
ÊËFGHIÎÏJKLM
NOÔPQRSTUÙ
ÛÜVWXYZŒ
«(&;!?)»

aàâbcçdeéèêëfg
hiîïjklmnoôpqr
stuùûüvwxyzœ

$1234567890£

French

Flamenco

AÀÂBCÇDEÉÈ

ÊËFGHIÎÏJKLM

NOÔPQRSTUÙ

ÛÜVWXYZŒ

«(&;!?)»

aàâbcçdeéèêëfg

hiîïjklmnoôpqr

stuùûüvwxyzœ

$ 1234567890 £

French

Binner

AÀÂBCÇDEÉÈ

ÊËFGHIÎÏJKLM

NOÔPQRSTUÙ

ÛÜVWXYZŒ

«(&;!?)»

aàâbcçdeéèêëfg

hiîïjklmnoôpqr

stuùûüvwxyzœ

$1234567890£

French

Century Schoolbook Bold

AÀÂBCÇDEÉÈ
ÊËFGHIÎİJKLM
NOÔPQRSTUÙ
ÛÜVWXYZŒ

«(&;!?)»

aàâbcçdeéèêëfg
hiîïjklmnoôpqr
stuùûüvwxyzœ

$1234567890£

Frisian

Frutus Regular

AÂBCDEÉÊFGHI
JKLMNOÔPQR
STUÚÛVW
XYZÆŒ
(&;!?)
aâbcdeéêfghijk
lmnoôpqrstuúû
vwxyzæœ

$1234567890£

German
Churchward Brush Wide

A Ä B C D E F G H I
J K L M N O Ö P Q R
S T U Ü V W X Y Z

« (& ; ! ?) »

a ä b c d e f g h i j k
l m n o ö p q r s t
u ü v w x y z ß

$ 1 2 3 4 5 6 7 8 9 0 £

German

Ultra Bodoni

AÄBCDEFGHI
JKLMNOÖPQR
STUÜVWXYZ

«(&;!?)»

aäbcdefghijk
lmnoöpqrst
uüvwxyzß

$1234567890£

German

Candida

AÄBCDEFGHI
JKLMNOÖPQR
STUÜVWXYZ

«(&;!?)»

aäbcdefghijk
lmnoöpqrst
uüvwxyzß

$1234567890£

German

Candida Italic

AÄBCDEFGHI

JKLMNOÖPQR

STUÜVWXYZ

«(&;!?)»

aäbcdefghijk

lmnoöpqrst

uüvwxyzß

$1234567890£

German

Impact

AÄBCDEFGHI
JKLMNOÖPQR
STUÜVWXYZ

«(&;!?)»

aäbcdefghijk
lmnoöpqrst
uüvwxyzß

$1234567890£

Old German
Schwabacher

UÄÅBCDEFGH

JKLMNOÖŐPQ

RSTUÜŬVWXYZ

aäåbcchckdeffffiflg

hijklmnoöőpqrs

ſſſſiſtßtßuüŭ

vwryz

&;!? 1234578900

Old German

Fette Fraktur

UÄBCDEFGHI
JKLMNOÖPQR
STUÜVWXYZ

«(&;!?)»

aäbcchckdefghijklm
noöpqrsßttzuü
vwxyz

$1234567890£

Old German

Fette Gotisch

A Ä B C D E F G H I

J K L M N O Ö P Q R

S T U Ü V W X Y Z

« (& ; ! ?) »

a ä b c ch ck d e f g h i j k

l m n o ö p q r ſ ß t

u ü v w x y z

§ 1 2 3 4 5 6 7 8 9 0 £

Greek

Grotesk Light

ΑΒΓΔΕΖΗΘΙΚ
ΛΜΝΞΟΠΡΣΤΥ
ΦΧΨΩ

αβγδεζηθικλ
μνξοπρστυ
φχψω

«(&;!?)»

$1234567890£

Greek

Grotesk

ΑΒΓΔΕΖΗΘΙΚΛΜ
ΝΞΟΠΡΣΤΥΦΧΨΩ

αβγδεζηθικλμνξο
πρστυφχψω

(&;!?)

1234567890

Greek

News Roman

ΑΒΓΔΕΖΗΘΙΚΛΜ
ΝΞΟΠΡΣΤΥΦΧΨΩ

αβγδεζηθικλμνξο
πρστυφχψω

(&;·ʿʾ!?)

$1234567890£

Greek

Eurogothic Light

ΑΒΓΔΕΖΗΘΙΚΛ
ΜΝΞΟΠΡΣΤΥΦ
ΧΨΩ

αβγδεζηθικλμν
ξοπροτυφχψω

(&;·!?)

$£
1234567890

Hebrew
Traditional

אבבגדרהווזחטיכ

כדדללממסנןוסע

פפפףצצץקקר

ששׂשׁתת

ָ ־ ֗ ֑ ֖ ֕ ֔ ׃ ָ ׃ ֓

✡

(…„""'ׁ'.-:..,,;!?. ˙)

1234567890

Hebrew
Modern

אבגדההוזחהטי
כךלמםננס
תפףצץק
רשׁשׂשׁת

("."!;,'")

1234567890

Hebrew
Adsans Bold

אבגדההוזח

טיכרלמסנום

עפכצצק

רשׁשׁת

✳

&;!?$£

1234567890

Hungarian

Avant Garde Medium

AÁBCDEÉFGH
IÍJKLMNOÓÖŐP
QRSTUÚÜŰ
VWXYZ
(&;!?)
aábcdeéfghií
jklmnoóöőpqrst
uúüűvwxyz

$1234567890£

Hungarian

Bramley Medium

AÁBCDEÉFGH
IÍJKLMNOÓÖŐP
QRSTUÚÜŰ
VWXYZ
(&;!?)
aábcdeéfghií
jklmnoóöőpqrst
uúüűvwxyz

$1234567890£

Icelandic

Optima Medium

AÁBCDÐEÉFGH
IÍJKLMNOÓÖP
QRSTÞUÚVW
XYÝZÆ
(&;!?)
aábcdðeéfgh
iíjklmnoóöpqr
stþuúvwxyýzæœ

$1234567890£

Icelandic (Old)

Zapf International Light

AÁBCDÐEÉFG

HIÍJKLMN

OÓǪǬØǾP

QRSTÞUÚV

WXYÝZÆǼŒ

(&;!?)

aábcdðeéfghií

jklmnoóǫǿøǿ

pqrstþuúvw

xyýzæǽœ

$1234567890£

ırısh
τRAOıτıonAl

AÁBCOEÉFȝGh
íÍJKlÌmnoÓpɋ
RSτúÚνwxyz

AÁbcoeÉFȝghıíÍj
KlÌmnoÓpɋRɼSr
τúÚνwxyz

(&7;!?)
$1234567789O£

Italian

Grotesk Medium

AÀBCDÈFGH
IÌJKLMNÒPQR
STUÙVWXYZ

«(&;!?)»

aàbcdeèfghiì
jklmnoòpqrst
uùvwxyz

$1234567890£

Italian

Arab Brush

AÀBCDÈFGH
IÌJKLMNÒPQR
STUÙVWXYZ

«(&;!?)»

aàbcdeèfghiì
jklmnoòpqrst
uùvwxyz

$1234567890£

Italian

Devinne Ornamented

AÀBCDÈFGH
IÌJKLMNÒPQR
STUÙVWXYZ

«(&;!?)»

aàbcdeèfghiì
jklmnoòpqrst
uùvwxyz

$1234567890£

Italian

Century Schoolbook Bold

AÀBCDÈFGH
IÌJKLMNÒPQR
STUÙVWXYZ

«(&;!?)»

aàbcdeèfghiì
jklmnoòpqrst
uùvwxyz

$1234567890£

Japanese

Hiragana

あいうえお　らりるれろ
かきくけこ　わゐんゑを
さしすせそ　がぎぐげご
たちつてと　ざじずぜぞ
なにぬねの　だぢづでど
はひふへほ　ばびぶべぼ
まみむめも　ぱぴぷぺぽ
やゝゆゞよ　っゃゅ よ

゛ 、。 ｜

¥1234567890$£

Japanese

Katakana

アイウエオ　ワヰンヱヲ
カキクケコ　ガギグゲゴ
サシスセソ　ザジズゼゾ
タチツテト　ダヂヅデド
ナニヌネノ　バビブベボ
ハヒフヘホ　パピプペポ
マミムメモ　ァィゥェォ
ヤヽユヾヨ　ッャュョヵ
ラリルレロ　ー、。｜

¥1234567890£$

Korean

ㄱ ㄴ ㄷ ㄹ ㅁ ㅂ ㅅ ㅇ ㅈ ㅊ ㅋ
ㅌ ㅍ ㅎ ㅏ ㅑ ㅓ ㅕ ㅐ ㅒ ㅔ ㅖ

ㄱ ㄴ ㄷ ㄹ ㅁ ㅂ ㅅ ㅇ ㅈ
ㅊ ㅌ ㅍ ㅎ ㄲ ㄵ ㄶ ㄹ
ㄻ ㄿ ㅀ ㅄ ㅆ

ㄱ ㄴ ㄷ ㄹ ㅁ ㅂ ㅅ ㅇ
ㅈ ㅊ ㅋ ㅌ ㅍ ㅎ

ㅗ ㅜ ㅛ ㅠ ㅡ ㅗ
ㅗ ㅜ ㅡ ㅛ ㅠ ㅗ ㅜ
ㅚ ㅘ

Lettish

ITC Symbol Book

AĀBCČDEĒF
GĢHIĪJKĶLĻM
NŅOŌPQRŖSŠT
UŪVWXYZŽ
(&;!?)
aābcčdeēfgģhiī
jkķlļmnņoōpqrŗsšt
uūvwxyzžæœ

$1234567890£

Lettish

Grotesk

AĀBCČDEĒFGĢH
IĪJKĶĻŅMNŅŌOPQR
ŖSŠTUŪVWXYZŽ

« (&;!?) »

aābcčdeēfgġhiīj
kķļmnņoōpqrŗsš
tuūvwxyzž

$1234567890£

Lithuanian

Memphis Medium

AĄBCČDEĖĘFGH
IĮYJKLMNOPQRSŠ
TUŪŲVWXZŽ

«(&;!?)»

aąbcčdeėęfghiįy
jklmnopqrsšł
uūųvwxzž

$1234567890£

Lithuanian

Euro Grotesk Bold

AĄBCČDEĖĘFGH
IĮYJKLMNOPQRSŠ
TUŪŲVWXZŽ

«(&;!?)»

aąbcčdeėęfghiįy
jklmnopqrsšt
uūųvwxzž

$1234567890£

Norwegian

Candida

AÅBCDEFGHIJK
LMNOPQRSTU
VWXYZØÆ

«(&;!?)»

aåbcdefghijklmno
pqrstuvwxyzøæ

$1234567890£

Norwegian

Clarendon Bold

AÅBCDEFGHIJ

KLMNOØPQR

STUVWXYZÆ

«(&;!?)»

aåbcdefghijkl

mnoøpqrstu

vwxyzæ

$1234567890£

Norwegian

Showcard Brush

AÅBCDEFGHIJK
LMNOPQRSTU
VWXYZØÆ

«(℥;!?)»

aåbcdefghijklmno
pqrstuvwxyzøœ

$1234567890£

Polish

Clarendon Light

AĄBCDEEFG

HIJKLŁMNNNOÓ

PQRSSTUVW

XYZZŻ

(&!;?)

aąbcćdeęfghijk

lłmnńoópqrsś

tuvwxyzźż

$1234567890£

Polish

Excelsior

AĄBCĆDEĘFGH

IJKLŁNŃOÓPQR

SŚTUVWXYZŹŻ

«(&;!?)»

aąbcćdeęfghijklł

mnńoópqrsśt

uvwxyzźż

$1234567890£

Portuguese

Century Expanded

AÀÂÁÃBCÇD
EÈÊÉFGHIÌÏÍJKLM
NOÒÔÓÕPQRS
TUÙÜÚVWXYZ

«(&;!?)»

aàâáãbcçdeèêéfgh
iìïíjklmnoòôóõpq
rstuùüúvwxyz

$1234567890£

Portuguese

Binner

AÀÂÁÃBCÇD
EÈÊÉFGHIÌÏÍJKLM
NOÒÔÓÕPQRS
TÙÜÚVWXYZ
«(&;!?)»
aàâáãbcçdeèêéfgh
iìïíjklmnoòôóõpq
rstuùüúvwxyz

$1234567890 £

Romanian
Grotesk

AÂĂÀBCDEÈFGHIÎÌ
JKLMNOÒPQRSȘ
TȚUÙVWXYZ

« (&;!?) »

aâăàbcdeèfghiîìjkl
mnoòpqrsșțțuù
vwxyz

$1234567890£

Romanian

Souvenir

AÂĂÀBCDEÈFGH
IÎÌJKLMNOÒPQRSȘ
TȚUÙVWXYZ

« (&;!?) »

aâăàbcdeèfghiîìjklmn
oòpqrsșțțuùvwxyz

$1234567890£

Romansh

Garamond

AÂĀBCDEÊĒÉFG
HIÎJKLMNOÔÖ
PQRSTUÜVW
XYZ
(&;!?)

aâābcdeêēéfghiîj
klmnoôöpqrst
uüvwxyz

$1234567890£

Sanskrit

अ आ ऋा इ ई उ ऊ ऋ ॠ ऌ ए ऐ

ओ औ क क कि कि खि ख ग ग घ च च्कृ च

ज्ञ ज फ ञ ञ ट ठ ड ढ या त त

य द ध्य घ न न प प फ ब भ म म य

र ल ल व व श श श ष ष स ह ह

ऋ क्ष द ज्ञ त्त ज्ञ ज्त त्त ह रु रू ट्ट द्द द्ध

ह्द ट्ट्र य श्र ह ल ह ह क्र ष्ट ष्ठ ङ ल्प

दृश्य म्य च्छ ध्य ह ण रङ ष्ण ब्र क्त न

ट द स्त्र म्य ॥ १ २ ३ ४ ५ ६ ७ ८ ९ ०

Slovak

Memphis Medium

AÁÄBCČDĎEÉ

FGHIÍJKLĽĹMNŇ

OÔPQRŔSŠTŤ

UÚVWXYÝZŽ

«(&;!?)»

aáäbcčdďeéfgh

iíjklľĹmnňoôpqrŕsš

łťuúvwxyýzž

$1234567890£

Slovenian

Nova Roman

ABCČDEFGHIJ

KLMNOPQRSŠT

UVWXYZŽ

(&;!?)

abcčdefghijklm

nopqrsštuvwxyzž

$1234567890£

Slovenian

Nova Bold

ABCČDEFGHIJ
KLMNOPQRSŠT
UVWXYZŽ
(&;!?)
abcčdefghijklm
nopqrsštuvwxyzž

$1234567890£

Spanish

Egyptian Bold Condensed

AÁBCDEÉFGH
IÍJKLMNÑOÓPQR
STUÚÜVWXYZ

«(&;¡!¿?)»

aábcdeéfghiíjkl
mnñoópqrst
uúvwxyz

$1234567890£

Spanish

Devinne Ornamented

AÁBCDEÉFGH
IÍJKLMNÑOÓPQR
STUÚÜVWXYZ

«(&;¡!¿?)»

aábcdeéfghiíjkl
mnñoópqrst
uúvwxyz

$1234567890£

Spanish

Clarendon Light

AÁBCDEEÉFGH
IÍJKLMNÑÓPQR
STUÚÜVWXYZ

«(&;¡!¿?)»

aábcdeéfghiíjkl
mnñoópqrst
uúvwxyz

$1234567890£

Spanish

Flamenco

AÁBCDEÉFGH
IIÍJKLMNÑOÓPQR
STUÚÜVWXYZ

«(&;¡!¿?)»

aábcdeéfghiiíjkl
mnñoópqrst
uúvwxyz

$1234567890£

Swedish

News Roman

AÅÄBCDEFGHIJ
KLMNOÖPQRS
TUVWXYZ

«(&;!?)»

aåäbcdefghijkl
mnoöpqrst
uvwxyz

+

$1234567890£

Swedish

Binner

AÅÄBCDEFGHIJ
KLMNOÖPQRS
TUVWXYZ

«(&;!?)»

aåäbcdefghijkl
mnoöpqrst
uvwxyz

$1234567890£

Tagalog

Palatino Bold

AÁBCDEÉFGG̃

IÍJKLMÑÑG̃

OÓPQRST

UÚVWXYZ

«(&;!?)»

aáàâbcdeéèêfgg̃
hííìîjklmnññ̃goóòô
pqrstuúùûvwxyz

$1234567890£

Turkish

Bodoni Medium

AÂBCÇDEFGĞH
IİJKLMNOÖPQRS
ŞTUÜÛVWXYZ

«(&;!?)»

aâbcçdefgğhiıjkl
mnoöpqrsşt
uüûvwxyz

$1234567890£

Turkish

Clearface Gothic

AÂBCÇDEFGĞH
IİJKLMNOÖPQR
SŞTUÜÛVWXYZ

«(&;!?)»

abcçdefgğhiıjk
lmnoöpqrsş
tuüûvwxyz

$1234567890£

Vietnamese
Baskerville Bold

AÁÀẢÃẠĂẮẰẲẴ

ẶÂẤẦẨẪẬBCDĐE

ÉÈẺẼẸÊẾỀỂỄỆFG

HIÍÌỈĨỊJKLMNO

ÓÒỎÕỌÔỐỒỔỖỘ

ƠỚỜỞỠỢPQRSTU

ÚÙỦŨỤƯỨỪỬỮỰ

VWXYÝỲỶỸỴZ

Vietnamese

Baskerville Bold

aáàảãạăắằẳẵặâấầẩ

ẫậbcdđeéèẻẽẹêếềể

ễệfghiíìỉĩịjklmno

óòỏõọôốồổỗộơớờở

õợpqrstuúùủũụư

ứừửữựvwxy

ýỳỷỹỵz

$1234567890 (&;!?)

Welsh

Grotesk

AÂÀBCDEÈÊËFGH
ÎÏÌIJKLMNOÔÖÒ
PQRSTUÛVWŴX
YŶŸZÆŒ

aâàbcdeèêëfghiîïìjk
lmnoôöòpqrstuûv
wŵxyŷỳzæœ
(&;!?)

$1234567890£